ESSENTIAL GUIDE TO
DRAWING
Animals

H46 570 174 5

ESSENTIAL GUIDE TO
DRAWING
Animals

A PRACTICAL AND INSPIRATIONAL WORKBOOK

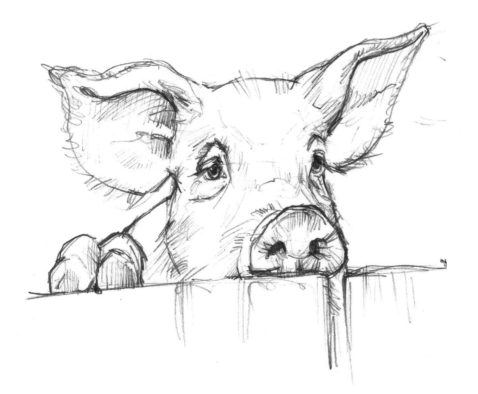

DUNCAN SMITH

ARCTURUS

About the author
Duncan Smith started drawing when he was a small child and hasn't
stopped since. Since graduating with Honours from the Glasgow School
of Art over 20 years ago, he has worked as a freelance illustrator for many
high-profile clients. He has written and illustrated his own children's books,
worked as a concept artist in the film industry and taught drawing classes
to adults and children. Duncan lives in London with his wife Nina, his
daughter Deepy, two cats and two wee dogs, Ted and Buffy.

ARCTURUS

This edition published in 2012 by Arcturus Publishing Limited
26/27 Bickels Yard, 151–153 Bermondsey Street,
London SE1 3HA

Copyright © 2012 Text and illustrations – Duncan Smith
Copyright © 2012 Design – Arcturus Publishing Limited

All rights reserved. No part of this publication may be reproduced,
stored in a retrieval system, or transmitted, in any form or by any means,
electronic, mechanical, photocopying, recording or otherwise, without
prior written permission in accordance with the provisions of the
Copyright Act 1956 (as amended). Any person or persons who do any
unauthorised act in relation to this publication may be liable to criminal
prosecution and civil claims for damages.

ISBN: 978-1-84858-810-3
AD002354EN

Printed in Singapore

CONTENTS

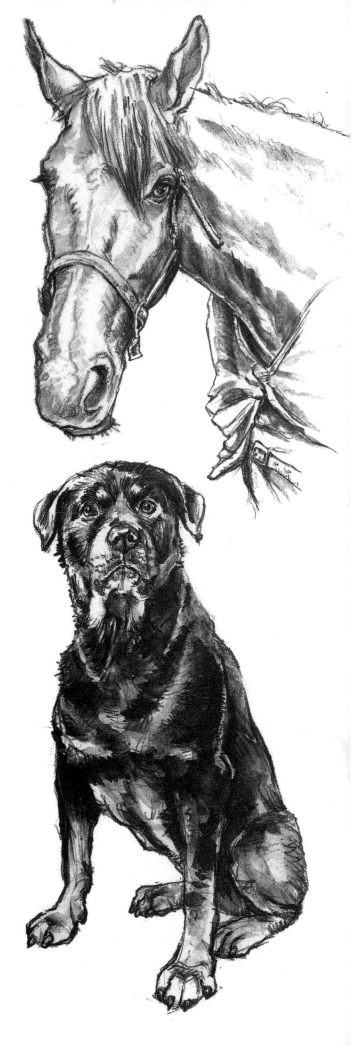

//// Introduction

When we were young, we would draw without hesitation or thought. 'Draw me a dog,' someone would say, and off we'd go and scribble away quite happily in a corner. A short time later we'd be back, announcing, 'This is the best drawing of a dog in the world, and can we put it on the wall now?' For when we were young we had no fear of drawing and there wasn't anything we couldn't draw.

Some people retain this ability into adulthood, and even manage to make a living out of it! However, most become too self-conscious once early childhood is past and simply give up after hearing one negative comment, their confidence destroyed. The classic line I often hear when people discover I'm an artist is, 'Oh, I wish I could draw.' Well, I'm here to tell you that **you can!** You've made the first step by buying this book. Drawing isn't a mystery – you don't need to have any special equipment, wear outlandish clothes, or look 'artistic' while drawing your subjects. You just need some paper, pencils and patience.

I know from my experience of teaching drawing classes and private students that everyone wants to just dive in and start drawing, but there are basic things you need to know. I've kept all the complicated anatomy and structure of animals to a minimum; if you need to go into this in depth at a later stage there are plenty of text books out there that will cover it in more detail.

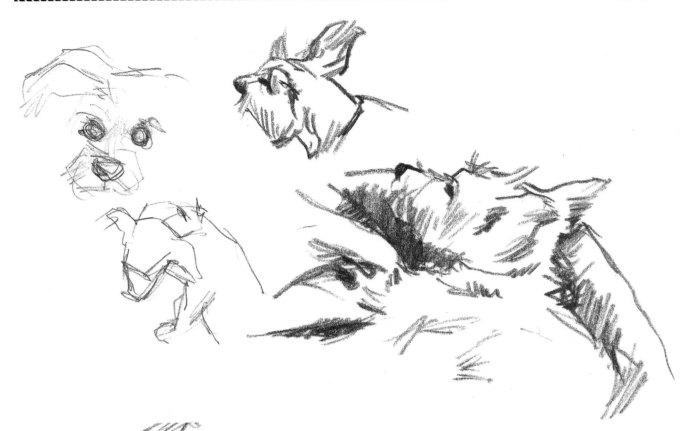

While the anatomy of any type of animal can be learned, trying to capture the character of a particular model is the tricky part, and if you're drawing from life you have to be quick. Animals don't stay still for long enough for you to do a finished piece, so use this time to practise quick sketches. This will allow you to be free with your technique and line, and you can use your sketches later for more finished work. When you want to do really detailed drawings, photographs are a great boon.

In this book I've tried to give you a simple guide to drawing your pets and other animals. By following the demonstrations and putting into practice the tips and shortcuts you'll find dotted throughout the book, you should achieve a set of drawings of a standard that may surprise you. This, I hope, will inspire you to continue on your journey to become an even better artist, taking creative chances and finding the style of drawing that suits you best.

////// Materials

As an artist, you will use a wide variety of materials and discover your particular favourites as you go along. Here I have listed some of the materials in my studio (you will find more on pages 40–47), but all you really need at first are some good pencils, a cartridge sketch pad, a putty rubber, a pencil sharpener, a little imagination and a lot of determination and you're all ready to start your adventure!

Pencils

I use only B (Black) grade pencils, as they are soft and you can easily achieve a wide range of tones from pale grey to jet black by varying the weight you place on your pencil. I favour a 3B pencil, and it's the one I start most drawings with. To find which you prefer, buy them in the range 2B to 8B (it doesn't matter which brand). The H (hard) grade pencils are more for technical drawing – they are very hard pencils and the marks they make are difficult to erase.

Derwent watersoluble sketching pencils

I use these a lot, as they are lovely pencils to sketch with. They work like watercolour – all you have to do is apply a wash of water with a brush and you can create wonderful tones in a very short time. After letting the washes dry you can apply more pencil lines to create darker tones, and with a little practice you'll be able to create quite finished detail work.

Eraser

There are many erasers on the market, and of these I recommend a putty rubber. It can be moulded into a nice point to remove just the fine lines you need erased, and unlike other erasers it leaves no debris behind.

Watersoluble brush pens

These are my choice for creating finished ink drawings. They are basically felt-tip pens, except that they have a proper brush at the end of the tip instead of a nib. You can make beautiful fine or thick lines and vary the line weight, just as with a regular brush, then, once you have inked up your drawing, you can paint into the image using a brush and water to create softer tones and washes. By working carefully and letting the washes dry between applications, it's possible to quickly build up a three-dimensional drawing.

Pencil sharpener or craft knife

I use a good pencil sharpener or a craft knife to make my pencils nice and pointy. It's easy to get so engrossed in your drawing that you don't notice that your pencils are becoming blunt, so you should aim to establish the habit of keeping your pencils as sharp as you can while you work.

Paper

Any good cartridge paper or pad will do for your purposes at first, though if you want to have a go at the illustrations here that use washes, it's best to use heavyweight (220gsm/100lb) cartridge paper. Layout paper is handy, as it will let you trace over your drawings to redo them or trace the finished drawings in this book. Later, when you feel more confident in your drawing skills, you can explore all the different types of paper suitable for drawing – watercolour paper for very heavy washes, Ingres paper for heavy pastel work and marker pads for any drawings with markers and fine pen work.

Making a Mark

Putting pencil to a blank piece of paper can be quite daunting, but be brave and make the first mark – you can always use your eraser, after all! Here are some examples of different line techniques to try.

Contour lines are used to define the outline of an object. You can also draw more complex contour lines across the surface of an object to help create its form.

'Tone' refers to the light and dark areas on an object, which are dictated by your light source. Practise creating tone or pattern by drawing a set of parallel lines then crossing over them with another set (see right). This is called cross-hatching.

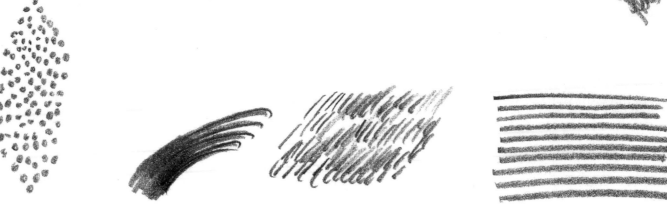

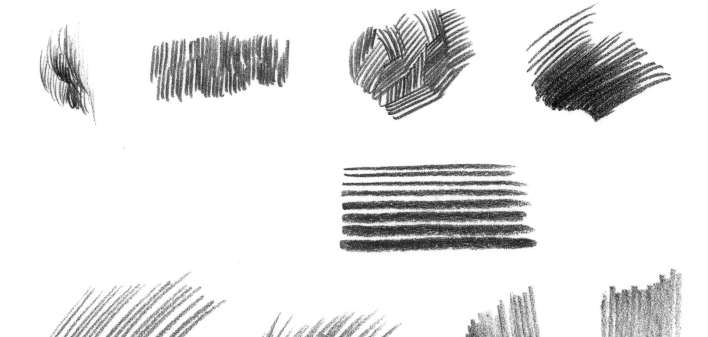

Now try to create graduated tone, using a 5B pencil. You can do this by gradually reducing the pressure on your pencil as you draw from heavy to light. Practise making marks and varying the amount of pressure you apply to see the effects you can achieve.

Creating Form

A drawing on a flat surface is two-dimensional, but there are ways of creating the illusion of three-dimensional objects.

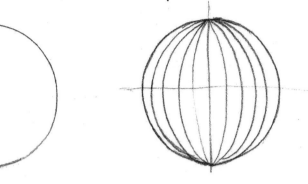
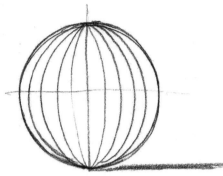

For example, this flat circle, when given a series of curved lines, appears to be a three-dimensional ball. Adding a few horizontal lines below creates a shadow so that it now appears to be resting on a flat surface.

These basic shapes all look two-dimensional and they are easy for even the most nervous beginner to tackle – but you'll soon see how some of them can be adapted to construct a drawing of an animal.

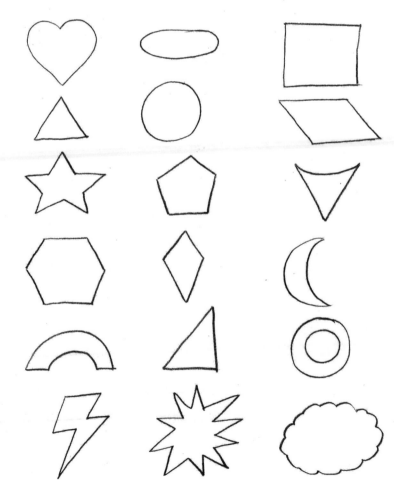

Drawing a fish

In this simple exercise you'll discover how to create an apparently three-dimensional fish from a two-dimensional drawing.

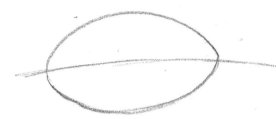

1. First, draw an oval and then a guideline through the middle.

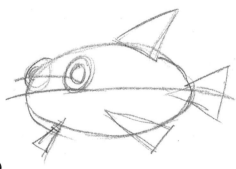

2. Next, add triangle shapes for the fins and tail and some more ovals for the eyes.

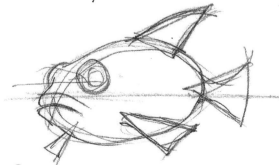

3. Below the guideline at the front, add a couple of downward lines to look like the fish's mouth.

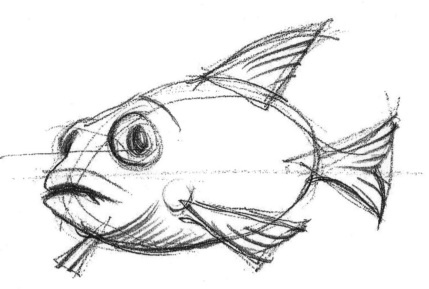

4. Darken the oval eyes and add pupils, then make the fins look more realistic by drawing slightly curved lines coming towards the fish's body. Add some tone to the underside of the fish by drawing contour lines that follow the shape of its belly.

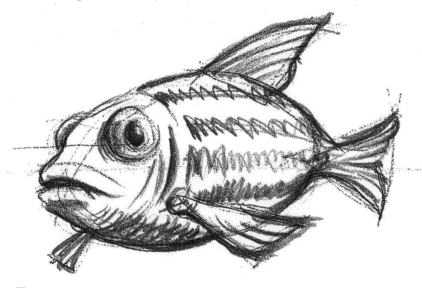

5. Make the lines of the mouth and the fish's outline stronger, using a darker tone. Add some wavy lines to create the pattern of the fish, which will also help to give it shape and weight. Finally, add some more darker lines to the underside to create the illusion of shadow.

13

Using Basic Shapes

One of the best ways to draw apparently complicated images of animals, and indeed people too, is to break them down into basic shapes to which you can then add detail.

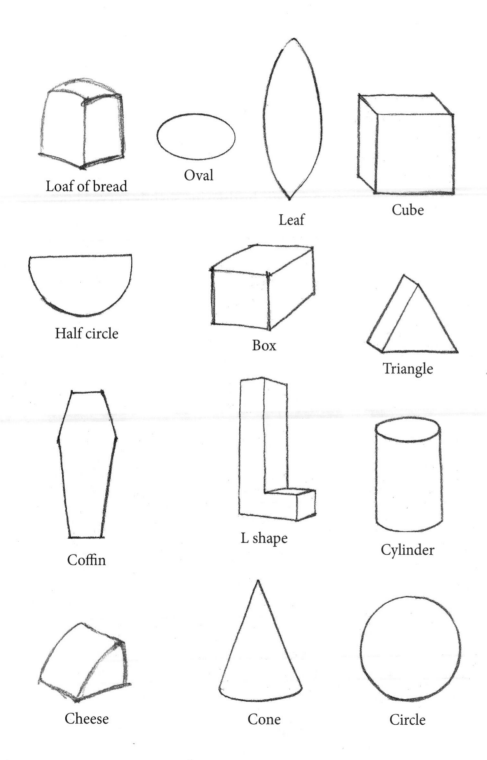

Loaf of bread

Oval

Leaf

Cube

Half circle

Box

Triangle

Coffin

L shape

Cylinder

Cheese

Cone

Circle

There are plenty of shortcuts that will help you to become an artist, and learning how to draw such shapes is one of them.

I've drawn some shapes here that will help you when you try some of the exercises in the book. Some of them, such as ovals and circles, will be more useful than others, but it's worth having a go at all of them. So, grab some pencils and paper and start copying them – don't worry if they're not perfect. The more you practise the easier they'll become, and you'll soon be able to draw them without hesitation.

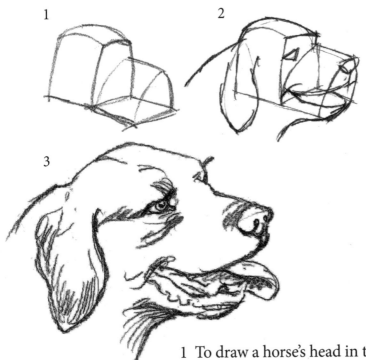

Now you've had a chance to draw some shapes, let's try drawing a dog's head, following the steps shown here. You'll be surprised at how quickly it comes together.

1 Draw a loaf of bread shape and then add a cheese shape on to it.
2 Draw some triangles for the eyes and nose, add some roughly leaf-shaped ears and don't forget the smiley open mouth.
3 Looking at the finished sketch, start to add some of the details like the tongue, lips and pupils of the eyes.

1 To draw a horse's head in the same way, first draw the coffin shape from the facing page. Roughly divide it into three parts; this will give you a guide for the position of the eyes and nose bone.
2 Add diagonal lines as shown, dividing the shape into several triangles. Add leaf shapes for the ears.
3 Roughly mark in the shape of the muzzle and cheekbones using curved lines and add more leaf shapes for the eyes, ears and nostrils. Draw two lines to suggest the projecting nose bone.
4 Take some time to add details to give your drawing a more finished look.

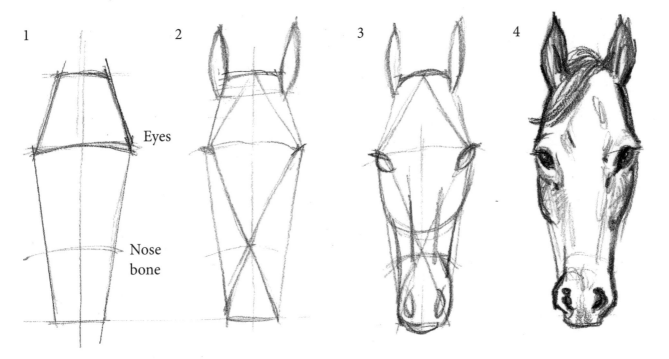

Simple Anatomy

Anatomy might sound daunting but it simply means the building blocks, or structure, of any subject, be it animal or human. Luckily for us, most animals have a similar anatomical structure.

The skeleton is the framework for the muscles and governs the movements that the subject is capable of. It's made up of numerous bones, but for the drawings in this book an advanced knowledge of the skeleton isn't needed.

First, here's a simple breakdown of the skeletons of a dog and cat which will help you to understand the basic structure of the animals. You can see that with a few lines and the help of some simple shapes you can create a basic dog and cat.

Next, a more detailed look with all the relevant parts of the structure labelled so you know where the joints are. Using human terms to relate the animal's skeleton to our own will help you to understand it better. At this stage it's important to take some time to copy these images and try to remember where the labelled parts are. Whether you draw from life or photographic reference you need to understand the basics, since knowing what's going on beneath the skin and muscles will give you confidence.

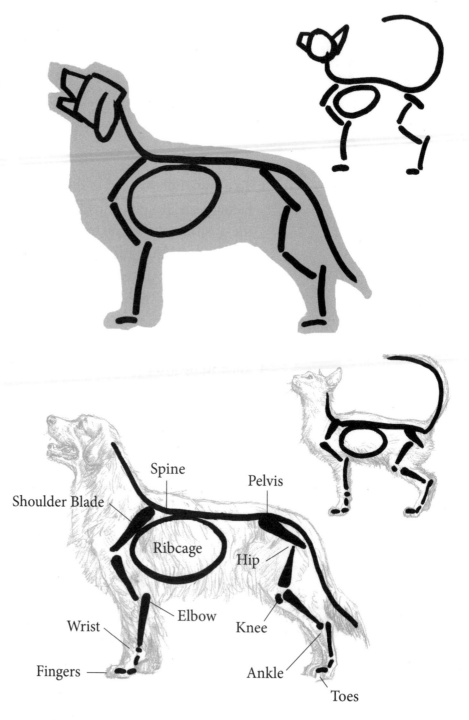

Spine

Pelvis

Shoulder Blade

Ribcage

Hip

Elbow

Knee

Wrist

Ankle

Fingers

Toes

Using these examples, try to copy
the finished dog and cat drawings,
using the simple line drawings you've
been practising.

Tabby Cat Step-by-step

This is a fairly simple drawing to start with; the pose is basically a big oval shape, so this means you can concentrate on the head and using the cat's stripey pattern to help create the shape of the body.

Materials and Equipment
3B and 4B pencils
220gsm (100lb) cartridge paper
Putty rubber
Pencil sharpener

1. The first thing I did was to make a little thumbnail drawing of the cat and mark in where I could see the darkest tones. Half-closing your eyes will help you to see the tonal values.

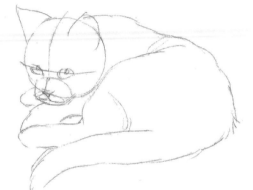

2. Next I drew a quick circle for the head and an oval for the nose area, then made a loose preliminary sketch of the body, tail and legs.

3. I started to erase some of the guidelines and add more detail, such as the pattern on the cat's head and back.

4. Then I concentrated more on the head, eyes and ears, using different pencil strokes and indicating the directions in which the fur lies.

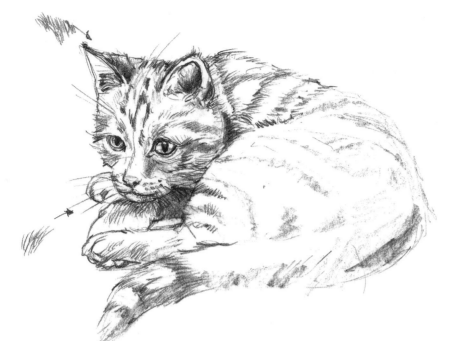

5. I was happy with the way the head and shoulders were progressing, so I started suggesting darker tones under the chin and on the paws and tail by using shading and hatching, referring back to my little thumbnail drawing that I did at the beginning to make sure I was getting the shapes right.

6. I created the illusion of the fur going around the cat's leg and body by following their contours, giving a three-dimensional look. Finally, I finished off the tail with some more hatching and I was done.

Rottweiler Step-by-step

Dogs are very expressive creatures, so when you draw them it's important to catch their character and pose.

Materials and Equipment

8B Derwent watersoluble sketching pencil (dark wash), or any similar watercolour pencil

220gsm (100lb) cartridge paper

Watercolour brush, No. 8 round

Putty rubber

Pencil sharpener

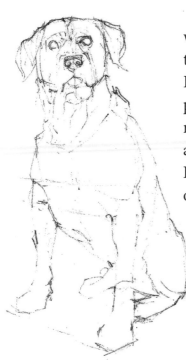

1. Using my Derwent watersoluble pencil, I sketched the dog in a loose manner. I checked that it looked in proportion, consulting my reference as often as needed and making any changes that I thought necessary to get the overall figure right.

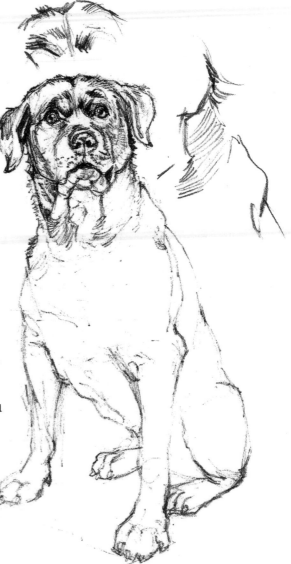

2. I like to start with the eyes – other artists leave them until the end, while some even believe you should start from the ground up. I feel I have to get the eyes right first before I move on.

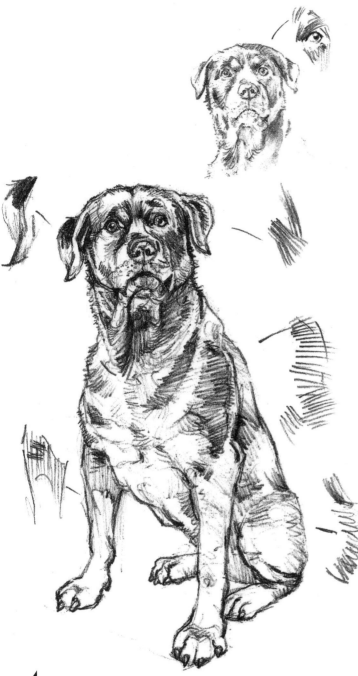

3. I added more detail to the body, following the lines of the dog's coat with a mixture of contour lines and hatching and shading. When I stepped back to look at the drawing (always a good idea as we get so wrapped up in drawing that we sometimes miss glaringly obvious mistakes), I realized I'd made the dog's ears too large. I decided to redraw the ears and alter the angle of the head slightly, so I grabbed my putty rubber and did some erasing. This is always a worrying time, in case the next attempt isn't as good – but when you know something isn't right, be brave. You drew it once and you can do it again.

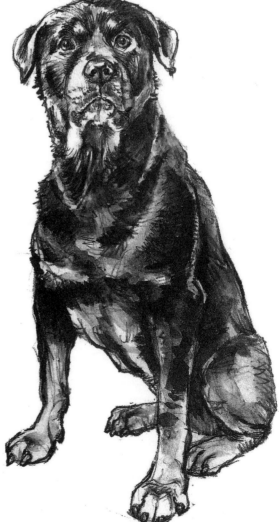

4. Once I had redrawn the head and ears I started to erase some of the guidelines. Now I was ready to add a wash to the drawing. I let a brush loaded with water glide over the drawing to give it an all-over tone. Once this was dry, I added slightly less water to the brush and worked into the areas where I had laid a heavier, darker tone. Where the wash was getting too dark or wet, I lifted off the surplus with a tissue; for areas that were too light, I used the watercolour pencil to draw back in and added a small wash.

Parrot Step-by-step

I found a lovely cheeky little parrot picture and thought it would be great fun to draw. These are particularly characterful birds, so the eye would be very important here.

Materials and Equipment

2B pencil

130gsm (60lb) cartridge paper

Putty rubber

Brush pen

Watercolour brush, No. 8 round

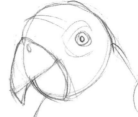

1. Using ovals and circles, I quickly drew the shape of a parrot's head with a pencil. Once I had established that I worked it up into an immediately recognizable representation of the bird and erased the guidelines. I darkened the eye, leaving highlights to give it life. Next I suggested the feathers on his head and breast and added some texture and scratches to his beak. That was as much as I needed to draw with the pencil – the brush pen would do the rest.

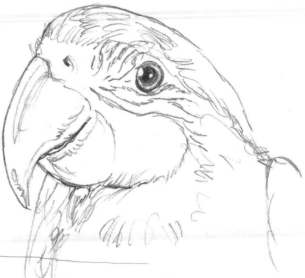

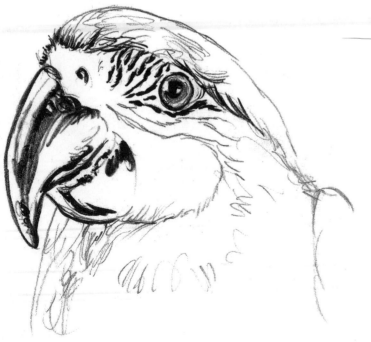

2. Next I went over my pencil lines with the brush pen, slowly building up the parrot into an ink drawing and adding more detail to the beak and chin.

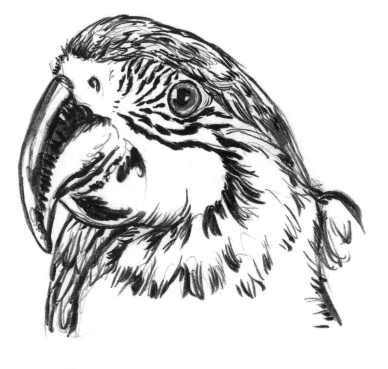

3. I continued to flesh out the bird, introducing darker tones where I would want more of a wash later. I concentrated on the beak area as I wanted a nice graduation here.

4. Putting down my brush pen, I picked up the brush and loaded it with water. I flooded the beak area under the highlight with water and let the wash do its business, keeping a tissue ready to soak up any overspills or excess water. Once I'd put a wash on, I dried my brush on the tissue and then immediately started to lift some of the wash I'd laid down – you can always darken an area again later, but it's more difficult to lighten it once it has dried. For the top of the beak I dipped my brush in water, mopped it so that there was just a hint of moisture on the brush, then followed the line of the beak, gently dragging the ink downwards. With a damp brush, I drew the ink up from under the neck feathers for the texture under the cheek and did the same above the beak. Using a light wash of water, I worked on the whole head. I used a damp brush around and in the eye, being careful not to muddy my highlights. I kept the patterned small feathers around the eye as dry as possible as I wanted these to remain strong blacks. I finished off with a damp brush beneath the feathers under the chin to suggest detail without there actually being much.

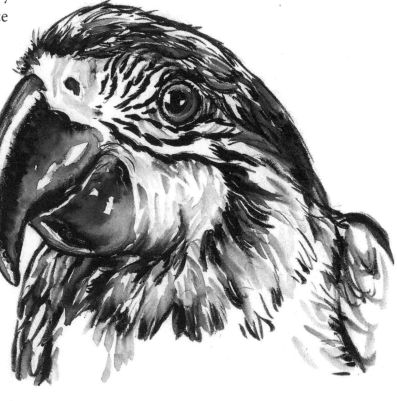

Always leave plenty of white paper showing – it adds sparkle and a suggestion of light to your finished piece.

23

Horse Step-by-step

I found this subject while visiting a local riding school, which is a great place to go if you need reference shots of horses. I made a quick thumbnail sketch of the horse as well as taking a few photographs.

Materials and Equipment
4B Derwent watersoluble sketching pencil (medium wash), or any similar watercolour pencil

220gsm (100lb) cartridge paper

Putty rubber

Watercolour brush, No. 12 round

Pencil sharpener

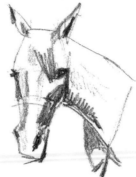

1. I set to work with my Derwent watersoluble pencil, sketching a rough outline of the horse's head and neck and a rug fastened over its chest. I divided the face into three sections to get the proportions right and took some time to position the features in the right place, referring to my photographs as often as I needed to.

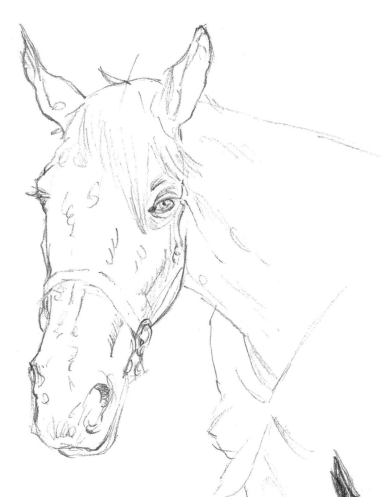

2. I began to work more on the eyes and nose, adding more detail and erasing whenever I needed to change something such as the size of the nostrils. I defined the mouth a little, sketching in a bottom lip and then removing my guidelines. Then I defined the ears and added some floppy hair for the forelock.

3. Next I put in additional details, varying the weight of my pencil line to create depth and light. I darkened areas such as the eyes, the hair and under the muzzle to create the illusion of depth by bringing the head into the foreground. I also added more detail to the bridle and some shadows above the nostril and the jawline.

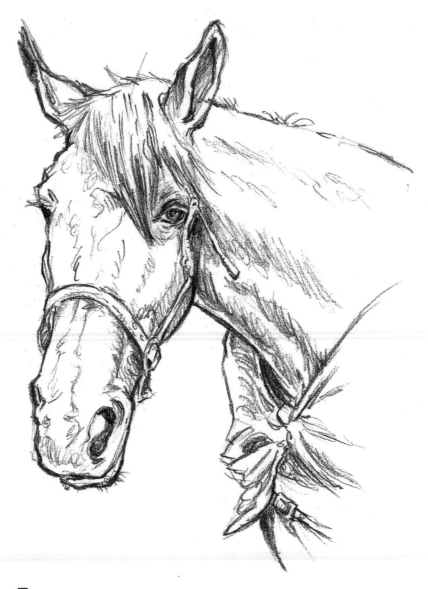

4. I used the pencil to give more emphasis to the darkest parts of the drawing, adding shadow under the jaw, eyes and muzzle. Putting the finishing touches to the horse's forelock, I left the paper blank in places to create the illusion of highlights between my varied pencil strokes. I also added more detail to the nose, ears, bridle and rug. Finally I added some wispy hair to the neck to suggest the horse's mane and a few hairs on his chin. I stepped back to view my drawing from a distance and decided that it was ready for the pencil wash.

5. The beauty of the Derwent watersoluble sketching pencil is that it allows you to create dark washes very quickly in a painterly way. By washing the water into the areas of dark tone with a large watercolour brush I gave the drawing deeper blacks, adding more water to soften areas of mid-tones. I gently brushed the water around the eyes and under the chin and neck to make the head stand out but left a lot of white paper to give the impression of light falling on the horse. I added a wash over the forelock and finished the rug, keeping my style as loose as possible. Overworking a piece can ruin a drawing; unless you want a photographic finish you don't need to add every eyelash and hair. It's an impression of the subject you want to achieve, hopefully having fun along the way.

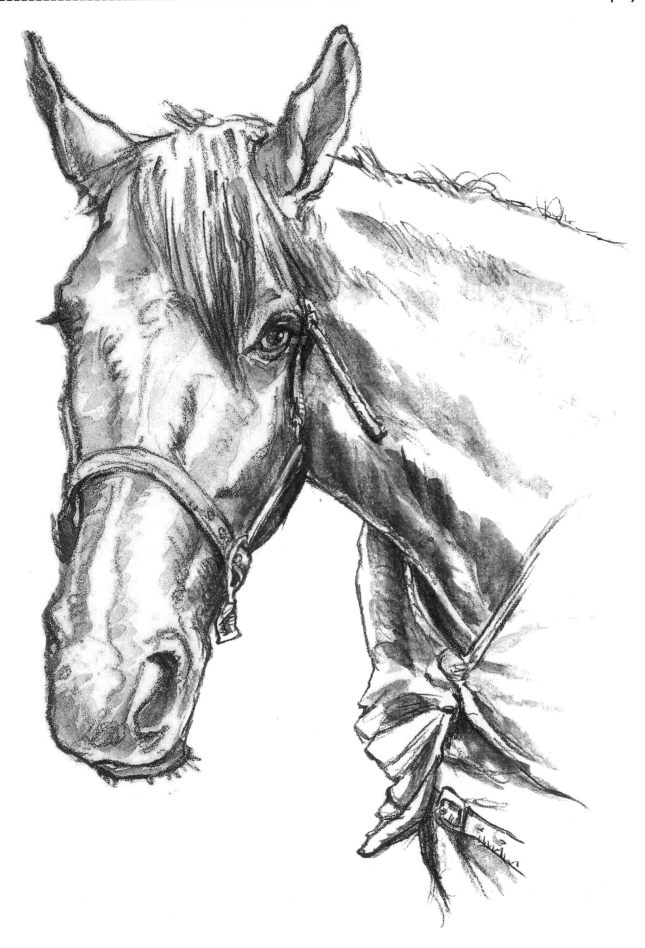

Using a Sketchbook

Sketchbooks come in all sizes from A6 to A1 and in styles from spiral-bound pads to handsome hardback books. I use an A4 sketchbook, treating it as a combination of notebook and diary for drawings. You can fill yours with doodles, ideas or finished drawings as you like – just try to make drawing in your sketchbook a habit, since doing this every day will help you to develop your style and dexterity with a pencil or pen and improve your observation skills too.

Charting your progress

It's a good idea to get into the habit of putting the date in the corner of the page when you have finished a sketch. That way, when you flip through the drawings, you'll be able to see the improvements in your work from the beginning until the present time. You'll be amazed by how quickly your drawing skills will improve with daily practice.

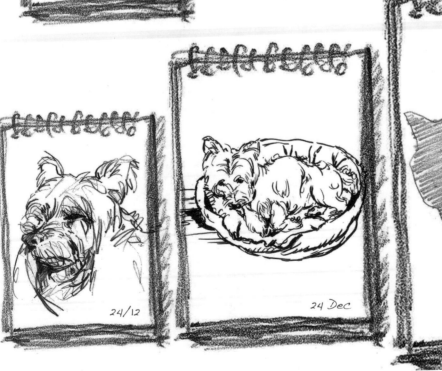

24/12

24 Dec

1 Jan

Fast sketches

When drawing for the first time, most people make the mistake of trying to draw everything in front of them. This can be overwhelming and leads to frustration and lots of pencils being thrown around the room. The beauty of fast sketching is that all you need to do is capture the important things – in the case of animals, the pose, the shapes and the expression. You can always go back to your sketch later if you want to develop it.

If you're drawing from life, you'll soon find out the animals hardly ever stay still for long, so fast sketching is your only option. There's an exciting challenge in that and it's great practice in drawing loosely and decisively, but if you do want to make a more considered sketch the best time to do it is while they're resting.

29

Down on the Farm

For many of us, the first place to find some animals of different shapes and sizes is on a farm – I've drawn a typical variety here. If you live in the country you probably have a choice available, while in urban areas there may be city farms that can be located by checking in your local library or directory or searching online.

Remember that your task here is not to do a finished detailed drawing, as you are learning about sketching and being able to do quick, loose drawings; if you do find a stationary subject you can take your time, but it's not the main event. Above all, have some fun and enjoy drawing out of doors.

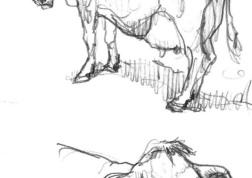

The best way to proceed is to choose what interests you and do plenty of sketches on each page so that if one subject moves away you can simply start on another – at the end you'll find that you have a page satisfyingly full of sketches. Take photographs of your subjects too, then you can do further work on the drawing with your photo reference in front of you when you get home.

Texture: Angora Guinea Pig

The main feature of this animal is its very long fur, which means that little of its body can be discerned.

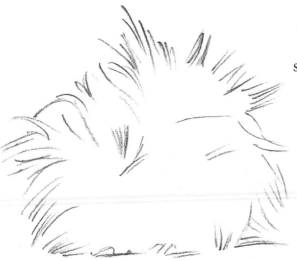

1. I started by drawing a fluffy ball shape, keeping the lines light and loose.

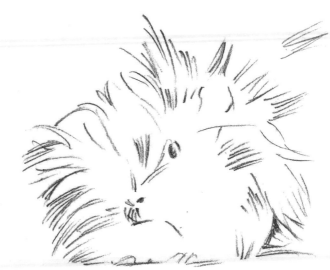

2. Next I added some more lines radiating out from the centre, then added a circle and something that looks vaguely nose-like.

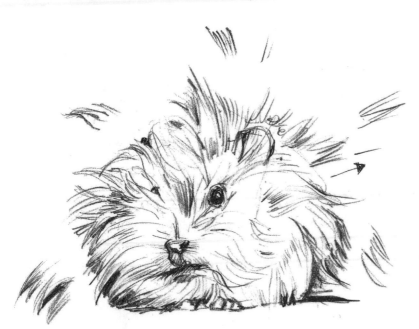

3. I darkened the eye and added one full ear and one that's partially hidden. Then I filled in the rest of the hair, keeping to the original shape. Finally I finished off the nose and added the mouth, moustache and beard, and part of the hidden eye before rendering the toes. I've added the types of lines and the direction they were drawn in so you can see how the drawing was built up.

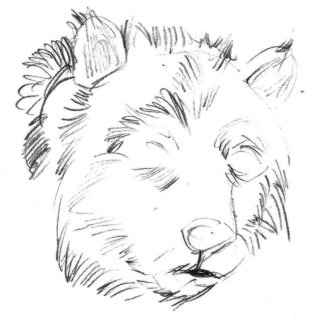

You may feel that rendering textures as different as fish scales and thick fur is going to be a huge challenge, but in fact all you need to do is use different marks with your pencil and carefully note how the light affects the surface.

As you can see from this preliminary sketch of a bear's head, I've created the shape of the head and suggested the eyes, ears, nose and mouth with just a few lines.

On the final, more finished drawing I've only added the details of the eyes, nose and mouth shapes, and the fur is just an elaborated version of the first sketch. I used more contour lines and some tone around the eyes and nose. This is still not a highly detailed drawing, but less is often more. I left a lot of white areas to create the suggestion of light, which in turn works with the dark tones to create a nice three-dimensional bear.

　　With any subject, you have to judge for yourself what's relevant to your drawing and refrain from including every detail for its own sake. In fact, once you become more confident in your drawing skills, try a looser, more impressionistic type of drawing as you develop your own style.

Here you can see an initial sketch of a Yorkshire terrier's tail (right), made by simply following the lines of the tail to give me the shape I needed.

Next I drew the whole dog using directional lines – there are no outlines here, just the shape the dog's coat makes as it twists and turns.

For the goldfish, I used a series of overlapping oval shapes to create the chain-mail texture of the scales that cover most of its body. It was important to emphasize the light here by using a dark pencil on one side of the scales to suggest it curving around the body. On the fins and tail the darker lines create the appearance of shadow, while the finer lines give the impression of light passing through the tail.

Find a reference picture and create something like the first image I've done here with the chimp, using only the contour lines of the hair on his body. In the second, smaller drawing, the contour lines are combined with an outline.

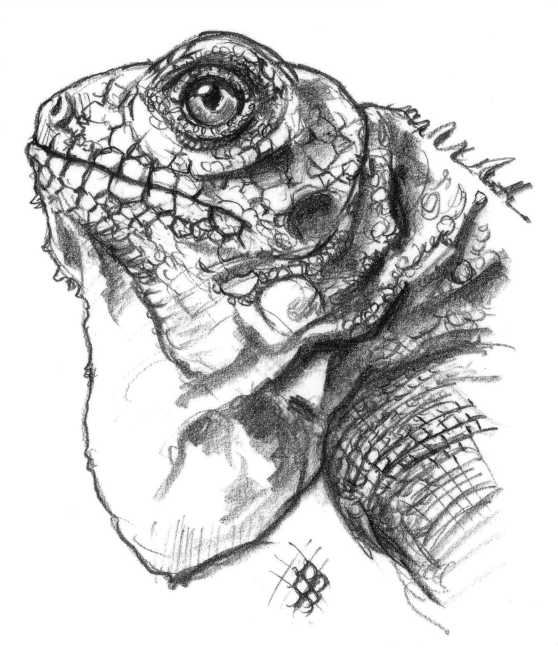

In the case of the iguana I've suggested the texture by adding detail in certain areas and leaving other areas just hinted at to avoid my drawing becoming too laboured and bogged down in detail. I created the chain-mail effect on the 'shoulder' by using a series of cross-hatched lines, with darker lines to represent shadow and finer, lighter lines to suggest light.

Around the mouth I built up what look like large tooth shapes, which then change into smaller diamond or hexagon shapes around the rest of the head. You can see I let these fade out until there's just a suggestion of them. The only area I gave detail to is the eye, which holds the piece together.

//// Using Tone

'Tone' refers to the light and dark areas found in any painting or drawing. Variations of tone graduate from white light through degrees of grey to the darkest black.

The use of tone helps the artist to create the illusion of three dimensions in a painting or drawing. In general, the light tones appear to be closer to the viewer whereas the darker tones help to make the image look further away.

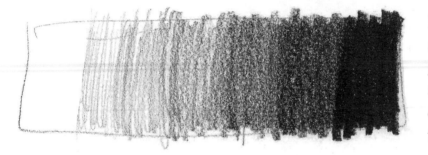

Here is an example of a tonal scale, which you can use as a guide when you're doing a tonal sketch. It starts at white and has deepening shades of grey right through to black.

Here I've used a version of the bird statue from the film *The Maltese Falcon*. I always think of film noir when I am making dramatically tonal drawings. Tonally this is a simple piece, but with the introduction of a black background it has an air of mystery and intrigue.

In the second drawing the falcon is set against a white background and here you can see the complete bird and the subtle graduation of tones as they disappear into the shadows. Notice how the surface of the table reflects light back on the base of the bird and how the main cast shadow, which is solid black under the bird, becomes a lighter mid-tone along its length.

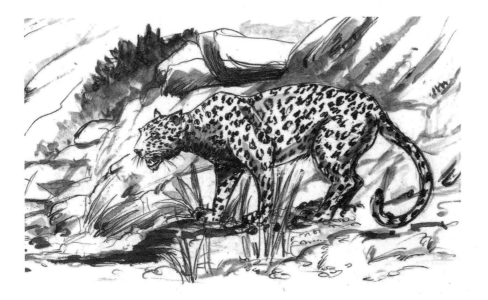

You can use various tonal values to lead the viewer through the image to the message you are trying to convey in your art. Here I have placed a dark shadow under the leopard to lead the viewer in the direction where the hapless meal might be.

The dark tones help to create the illusion of the leopard's body being three-dimensional. The dark shadow on the left grounds her and the reflected light on her belly helps to complete the trick.

The labrador watercolour called for a more subtle use of tones. There's the inherent tone of the dog's body and then various tones that create the idea of the soft coat. The slight suggestion of dark tone under the mouth and tongue helps the viewer to believe the depth of the mouth, while the lighter tone of the gums gives you the feeling that they are in front of the tongue. The highlights on the nose make it look as if you could reach out and touch it.

Toned and Textured Paper

Drawing on white paper means that you start making your marks on the lightest tone possible. Using toned or textured papers instead makes a change and is great fun. Toned paper allows you more time to work on your highlights and either mid-tones or dark tones, depending on the tone of your paper.

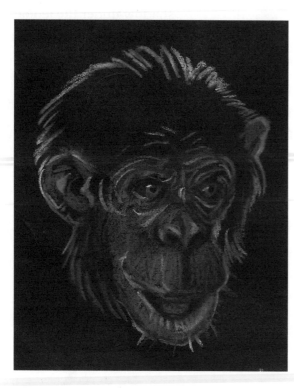

Chimp

First I pencilled in the head of the chimp, leaving the black of the paper blank to create his hair. A pale grey pastel pencil gave me the mid-tones around the face, leaving the dark of the paper showing through here and there. I used a black pastel pencil to add the blacks of the eyes, nostrils and mouth. Then I pulled the drawing together with a white pastel pencil to bring out all the highlights, including a rim light around the back of his head to separate him from the background.

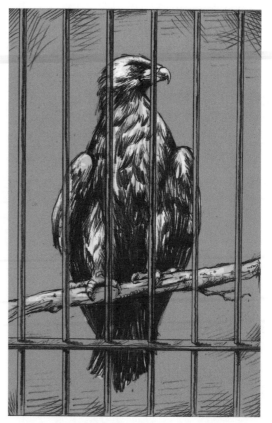

Eagle

The eagle is actually a black and white pencil drawing on regular white cartridge paper, but I thought I'd include a 21st-century version of toned paper using the computer. I scanned in the drawing and, using Photoshop, added another dark grey layer. With the eraser tool in the program, just like a real eraser or a white pencil, I started adding highlights to suggest the strong light source. It was quick and easy to do but very effective.

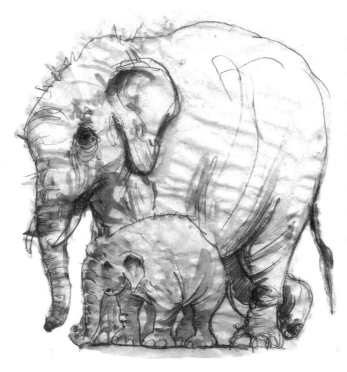

Elephants

To demonstrate that you don't need special paper, I did this drawing on an old scrap of cheap photocopy paper. I drew with an 8B watersoluble sketching pencil and then quickly washed in some dark tones on the elephants, making the wash slightly wetter than I normally would to achieve a leathery texture. I blotted off the excess water with some kitchen paper and found it left some lovely textured lines.

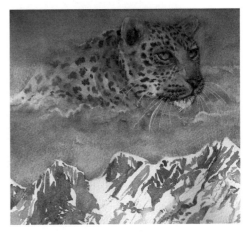

Leopard

This drawing, done some while ago as a cover for a book, is in watercolour on a heavyweight Rough watercolour paper. This has a textured surface that enhances the atmosphere in the painting.

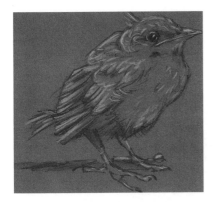

Bird

This little bird was hopping about under our tree, trying to fly. We looked after him for a few days, after which he flew off – but before he did, I managed to make a few sketches of him. Here I used an 8B watersoluble sketching pencil on grey-toned paper, washing in the mid-tones lightly then finishing off with a white pastel pencil for the highlights. Only the initial drawing was done from life – he didn't stay still for long.

Sparrow

I found this dead sparrow at the bottom of the garden, still intact. I thought it should be immortalized, so I pulled out my sketchpad, which has handmade paper with a rough texture to it. I set to work with my watersoluble pencil along with a brush and water to make washes. I tried to keep the drawing quick and loose and am especially pleased with the way the coarse texture of the paper enhances the drawing.

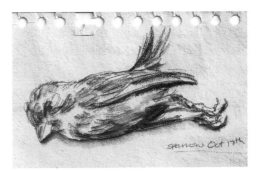

Ink

Applied by brush, dip pen or brush pens, ink can produce a clean dark line or solid black. As it can't be erased, you need a certain amount of practice to become comfortable with this medium – though if need be you can cover up mistakes with white ink or gouache. Here are some examples of ink drawings, showing the different effects you can achieve. Brush pens are a particular favourite of mine, and you will already have seen them used elsewhere in this book.

Here I used a brush pen and kept the line as fluid as I could, sweeping the fur lines away from the cat to suggest its movement. Because it was a black cat I also used a brush pen which was running out of ink to give it some lighter tone so that it didn't become a solid black.

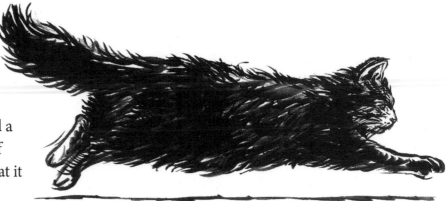

These ducks were drawn on location in pencil – I just sat by the river and did a quick sketch. When I got home I used a brush pen to ink in the drawing.

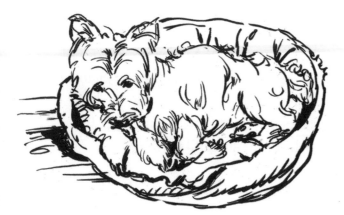

There was no underdrawing here – I tried to capture my dog Ted with a brush pen as quickly as I could before he moved! I kept the lines to a minimum to suggest only what was needed.

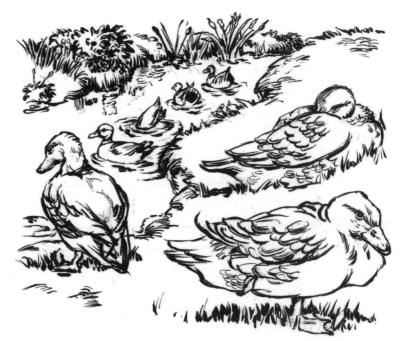

This cat moved too fast for me to draw, so I took some photographs and pencilled in a quick sketch, which you can probably still see. He was done with a brush and dip pen, which has a drawing nib for dipping into your ink bottle.

Both cows were drawn with a Japanese brush pen. I kept them both clean and fairly graphic.

Using a mixture of brush pens both new and old, I created the softer tones of this peacock with the brush that was running low on ink and drew the dark blacks where the shadows fell with the new pen.

Watercolours

It takes a lot of patience and experimentation to master watercolours – I've been using them for over 25 years and I'm still learning! But watercolour is a great way to make your drawing come to life and it will be easier to handle if you follow a few basic rules.

The first is to work on fairly heavyweight watercolour paper. This comes in pads or individual sheets; I recommend a Bockingford watercolour 300gsm (140lb) pad. As the name of the medium suggests, you'll be using water, so you need a paper heavy enough to hold the wash without buckling.

In watercolour you always work from light to dark, building up your washes of colour (or in our case greys) one after the other, finishing with your darkest tones. Watercolour is a light and bright medium, but it can also give you deep dark shadows and a detailed painting if you so wish. Shown here is a variety of watercolour pictures, from the fully rendered to the light and breezy wash type.

The parrot was a detailed painting which took a lot of time, as I had to build up the layers of washes. I lifted out a lot of the highlights using a brush and water and tissue. The feathers on the wing and tail were achieved using wet-into-wet technique, with some of the highlights added with white gouache once the watercolour was dry.

The kitten was painted fairly loosely, though I took my time to work on the details in the basket.

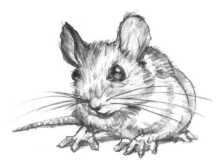

For this mouse I used an 8B watersoluble sketching pencil, drawing quickly but paying attention to detail on the head and paws. I then used a brush and water to create the wash.

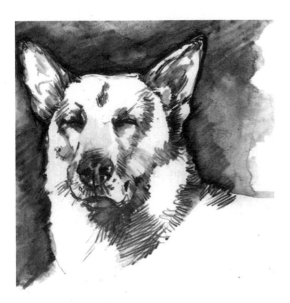

This German shepherd dog was drawn with watersoluble pencil followed by washes of water, but while the washes were still wet I added more pencil lines – almost the classic wet-into-wet watercolour technique of dropping paint into a previous wash that is not yet dry. Don't be too precious with your work – experiment freely, since you never know what you might come up with.

Here I used wet-into-wet technique. After the initial sketch, I covered the image with water and while it was still wet I added the tones, gave them a minute to partially dry then added the next tones. This allowed the paint to gently bleed together, giving this nice soft feel.

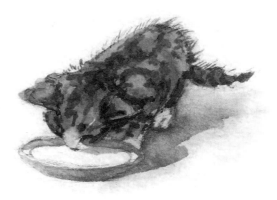

My selection of dogs wearing sunglasses was done with a watercolour pencil. It was very quickly drawn and washed in as I wanted it to stay fresh and light.

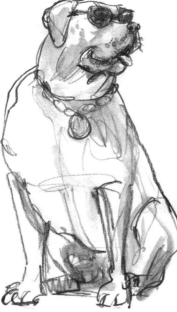

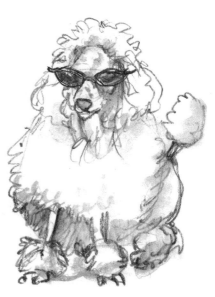

Charcoal

You'll find that charcoal is a great tool for drawing, since it can not only give wonderful rich blacks but also beautiful subtle tones. This makes it a very versatile medium and one that I hope you'll enjoy using.

Before you start a complete drawing, do some quick sketches first to familiarize yourself with using the charcoal sticks. When you want to add fine detail, use the point of the charcoal stick; for covering areas with tone, work with the side of it. This way you'll see the different marks and subtle tones that can be achieved. Charcoal can be very messy but very rewarding – it just takes a little care and planning first. When you have done a drawing you're pleased with, spray it with fixative bought from an art supplies shop so that it doesn't smudge.

Poodle step-by-step

The woolly coat of a poodle lends itself well to treatment with charcoal to convey its softness and density.

Materials and Equipment
3B pencil
220gsm (100lb) cartridge paper
Willow charcoal sticks, medium-hard
Dark charcoal pencil
Putty rubber
Watercolour brush, No. 2 round

1. First I did a very basic sketch of the poodle with a 3B pencil to make sure I got the shape right.

2. I broke a stick of willow charcoal in half, which makes it more manageable to use and gives you a sharp edge for detail. Checking my reference picture, I began to follow where the shadows and tones were and drew these in. Where the dark shadows were I made these marks heavier and then, with my finger, smudged them towards where the light was falling to create the blend of tone. You can use something called a smudge stick to do this, but I prefer to get my hands dirty.

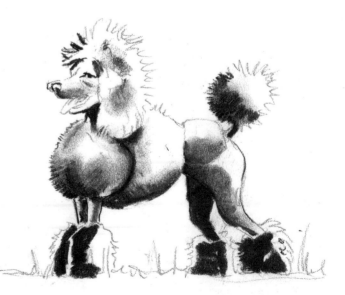

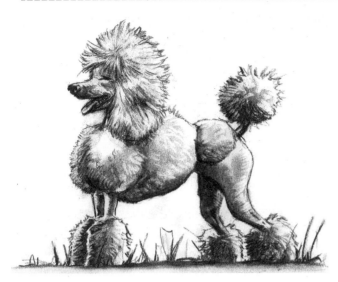

3. I started to add detail in the face by using the charcoal stick and charcoal pencil. Next I blended all the areas on the body and put in some details to the hair and head, using the putty rubber to lift out light areas. I also created a light area under the near hind leg to give a suggestion of the light hitting it and lifted out the highlights on the dog's coat. With the fine end of the charcoal stick, I drew some lines around the body and hair.

4. I decided to add a dark background to emphasize the whiteness of the dog's fur. To do this I drew a heavy black outline carefully around the dog with a charcoal stick, then, with a paintbrush, start to dust away from the line, creating a dark tone behind the dog. I took care not to go right up to the line with my brush otherwise it would be lost.

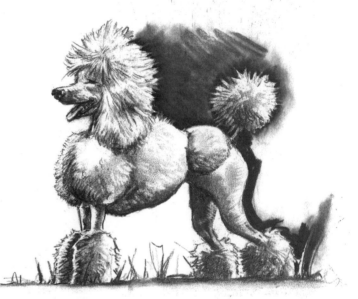

5. My final task was to lift out any details in the hair and any areas that looked smudged. I also noticed that I had lost the dog's neck! Mistakes such as this often happen when you get caught up in your work, which is why you should keep stepping back from it to assess it. I used the putty rubber to draw in a new neck and also altered the front leg so it now sits better under the body.

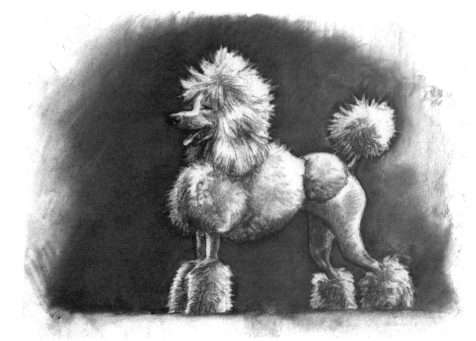

//// Pastels

For many artists, pastels are a great medium because they can be used to create highly finished pieces or vibrant impressionistic work; Degas, Renoir and Toulouse-Lautrec are among those who have worked extensively with them. They come in three types: soft, hard and oil pastels.

Materials and Equipment

Pastel pencils

Soft pastels

Ingres pastel paper pad

Charcoal pencil

Watercolour brush, No. 2 round

Putty rubber

Pencil sharpener/craft knife

Pastel cat step-by-step

I decided to use a rather rotund feline friend with plenty of soft fur for this pastel demonstration.

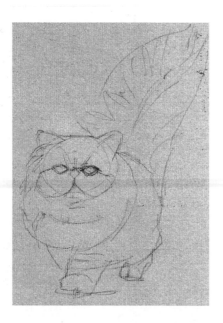

1. I began with a quick sketch done in pastel pencil to get the shapes down on paper.

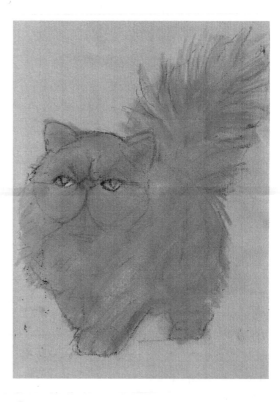

2. Next, with a mid-tone pastel, I filled in the whole image, taking my time at the tail and following the shape of the long hair.

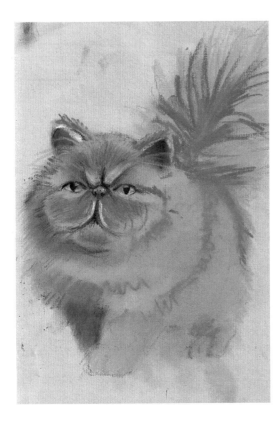

3. Here I started to blend the mid-tones using my watercolour brush. Using a slightly darker-toned pastel, I added the fur around the face and tail section. I started on the eye with a charcoal pencil and added detail, then darkened the inner ears with my darkest pastel.

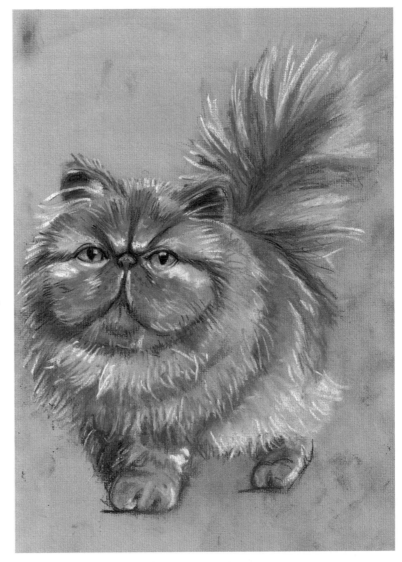

4. After adding more detail all over to suggest the hair of the cat, I worked over the dark and mid-tones with a white pastel to add the highlights, using alternately pastel pencils and pastel sticks to do this job. Finally, I darkened some of the areas that had been smudged and then tightened up the eyes, nose and brow area. Those were the only parts where I wanted detail – the rest was kept loose.

When you've finished your pastel or charcoal drawing you can spray it with fixative to stop it smudging. Do this out of doors to avoid inhaling it, as it is toxic.

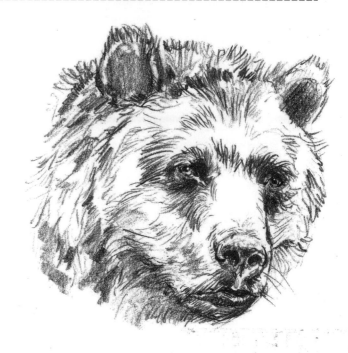

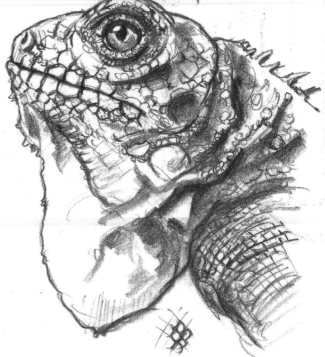

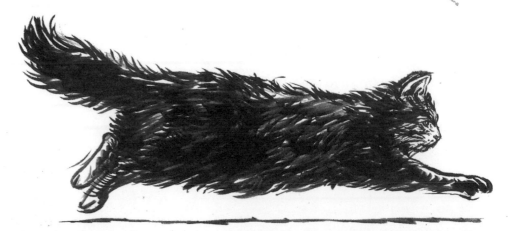